'50
e

YOU CAN
Draw
DINOSAURS
& OTHER PREHISTORIC ANIMALS

BY THE EDITORS OF CONSUMER GUIDE®

Publications International, Ltd.

Contents

Louis Weber, C.E.O.
Publications International, Ltd.
7373 North Cicero Avenue
Lincolnwood, Illinois 60646

Printed in Yugoslavia.

h g f e d c b a

ISBN 0-88176-604-6

Illustrators: Bob Walters and Mike Manley

Introduction

The easy, step-by-step instructions on the following pages can turn you into an artist. Anyone can do it.

All you need is a No. 2 pencil, a pencil sharpener, and an eraser. Then use *You Can Draw Dinosaurs & Other Prehistoric Animals* to practice drawing these "terrible lizards."

Each drawing begins with a few simple shapes printed in red ink. The second step shows the first drawing in black, with new shapes and marks in red. This shows you how to make step one's drawing look like that in step two. The steps that follow also show the earlier drawings in black and the new marks and shapes in red.

Blank space near each step lets you practice your drawing skills. You can also compare your drawing with the printed one. Draw lightly with your pencil. This makes it easier to erase mistakes and other marks that change slightly in later steps. When you are done, use a pen or fine felt-tip marker to darken the pencil marks that make up the finished drawing. Then gently erase any remaining pencil marks.

When you are done, you will have 17 drawings of the bodies and closeups of the heads of dinosaurs and other prehistoric animals.

If you wish, you can add color by using crayons, colored pencils, or markers. You may want to cut out your drawings, and tape or glue them onto colored construction paper. Then you will be the proud owner of an art collection of creatures from the past. Have fun.

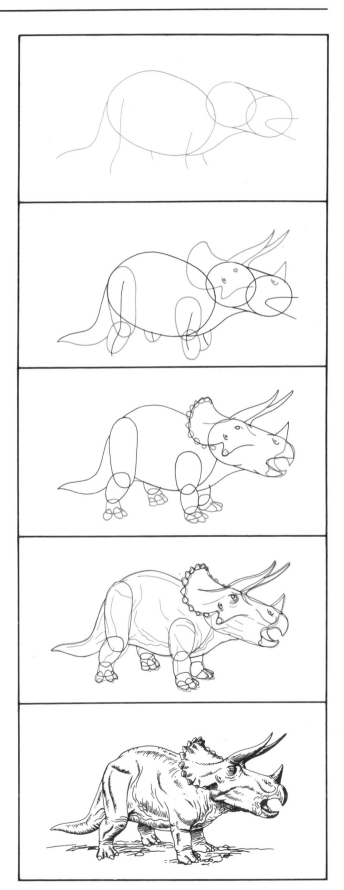

Parasaurolophus (head)

1 Draw an oval for the head. Add the letter V to show the position of the mouth. Use gently curved lines to form the neck and top of the crest.

2 Show the positions of the eye, ear, and nostril. Sketch gently curved lines to complete the remainder of the crest.

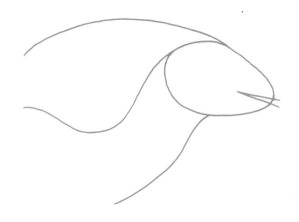

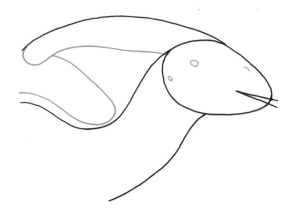

For each step, draw lightly with your pencil.

3 Make the mouth, beak, and jaw look more real. Use a gently curved line to connect the jaw to the neck.

4 Smooth out all of the lines. Add more details around the eye, ear, and nostril. Sketch gently curved lines to make the neck look more muscular and to show the ridges in the crest.

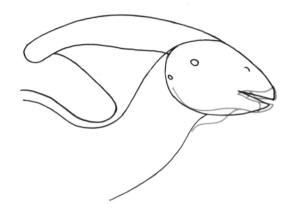
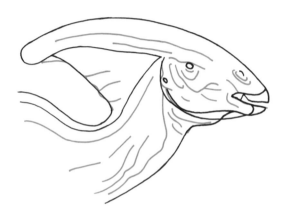

Use a pen on the final drawing; then erase pencil marks.

Parasauropholus continued

5 This is a detailed example of how the head of the Parasaurolophus might have looked. Finish the drawing as shown here or try another idea of your own.

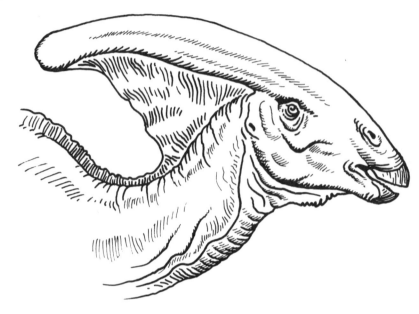

For each step, draw lightly with your pencil.

Pteranodon

1 For the head, draw a small circle. Add the letter V twice to show the beak and jaw. Sketch a bent line to form the top of the crest. Draw a small potato shape for the body. Use an upside-down capital T to form the shoulders and right side of the neck.

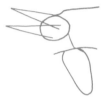

Pteranodon continued

2 Draw overlapping carrot shapes to show the positions of the arms and legs. Add the eye. Sketch gently curved lines to form the bottom of the crest and the tops of the wings.

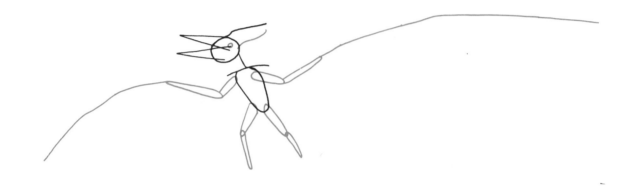

For each step, draw lightly with your pencil.

3 Make the mouth, beak, and jaw look more real. Add the left side of the neck. Use gently curved lines to show the positions of the fingers, toes, and claws, as well as the bottoms of the wings and wing bones. Draw an upside-down V to form the skin flaps between the legs.

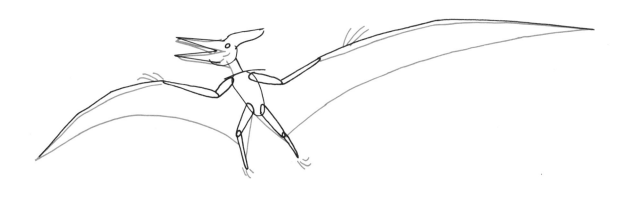

Pteranodon continued

4 Smooth out all of the lines. Use curved lines to connect the shoulders to the wings and to show the ribs, shoulders, arms, and legs. Make the mouth, wing bones, arms, fingers, feet, toes, and claws look more lifelike. Add the nostril and more details around the beak, jaw, eye, and crest. Draw straight lines in the wings.

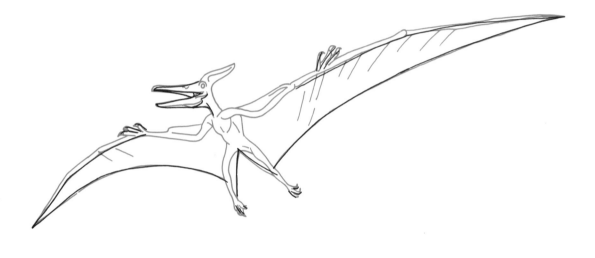

For each step, draw lightly with your pencil.

5 This is a detailed example of how the Pteranodon might have looked. Finish the drawing as shown here or try another idea of your own.

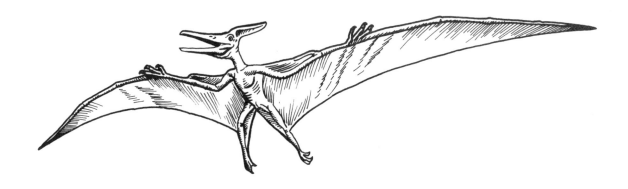

Ceratosaurus (head)

1 Draw a circle for the head. Sketch a large U-shaped figure for the snout. Use the letter V to show the position of the mouth. Add a gently curved line for the top of the neck.

2 Draw the eye, nostril, and ear. Sketch gently curved lines to form the jawbone and underside of the neck. Make the beak, jaw, and mouth look more lifelike.

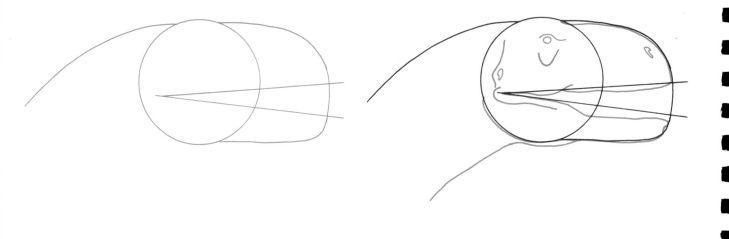

For each step, draw lightly with your pencil.

3 Use odd-shaped triangles for the snout's horns. Add a wavy line to show the back of the head. Connect the last horn to the wavy line at the back of the head. Sketch another wavy line on the neck. Draw small ovals near the top of the neck. Add small uneven V-shaped figures to form the teeth.

4 Smooth out all of the lines. Add the tongue and more details around the eye, nostril, and mouth. Sketch many curved lines to make the neck look wrinkled. Add a curved line at the base of the rear horn.

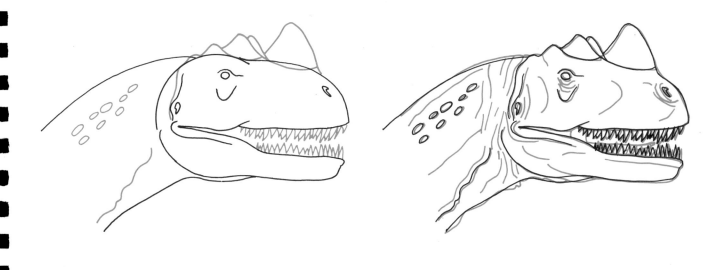

Use a pen on the final drawing; then erase pencil marks.

Ceratosaurus continued

5 This is a detailed example of how the head
of the Ceratosaurus might have looked.
Finish the drawing as shown here or try
another idea of your own.

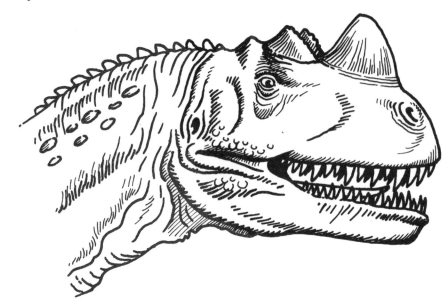

For each step, draw lightly with your pencil.

Tyrannosaurus rex

1 For the head, draw an oval that is slightly
square. Add the letter V for the mouth. Sketch a
large oval for the body. Use gently curved lines to
show the top of the neck and the positions of the
two back legs.

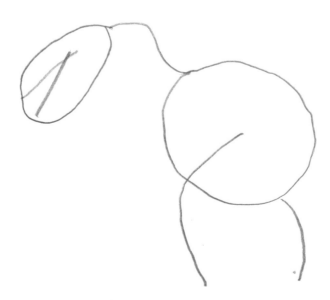

Tyrannosaurus rex continued

2 To form the legs, draw overlapping ovals and U-shaped figures. Sketch gently curved lines to show the underside of the neck and the top of the tail. Add the eye, ear, and nostril.

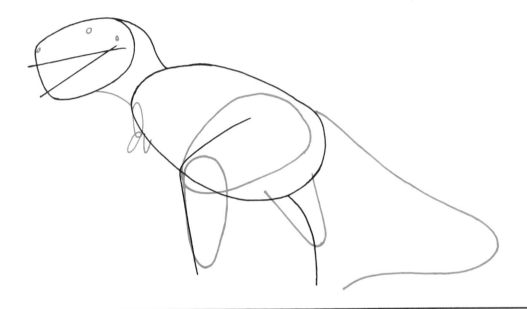

For each step, draw lightly with your pencil.

3 Draw short straight lines to show the positions of the teeth. Make the head, mouth, beak, and front legs look more real. Sketch gently curved lines to form the shoulder, neck, and the rest of the tail. To show the positions of the back feet, draw two triangles.

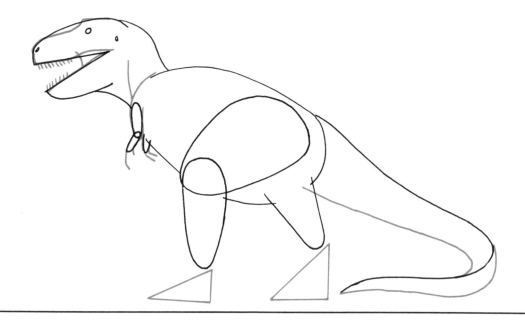

Use a pen on the final drawing; then erase pencil marks.

Tyrannosaurus rex continued

4 Smooth out all of the lines. Make the teeth, mouth, feet, toes, and claws look more lifelike. Use curved lines to show the ribs and the shoulder and hip bones. Make the neck, body, legs, and tail look more muscular by drawing curved lines. Add more details around the beak, jaw, eye, and ear.

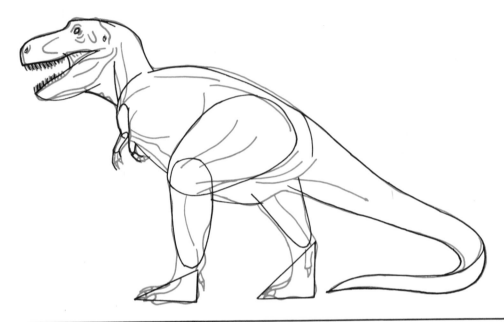

For each step, draw lightly with your pencil.

5 This is a detailed example of how the Tyrannosaurus rex might have looked. Finish the drawing as shown here or try another idea of your own.

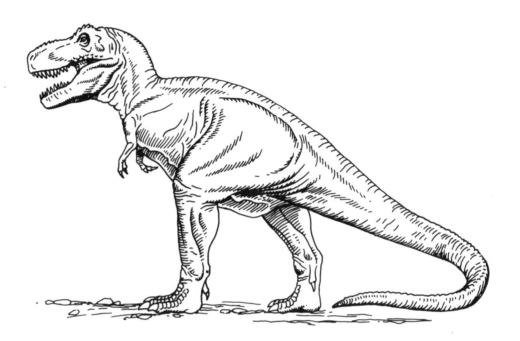

Coelophysis

1 Draw a circle for the head. Add the letter V to form the mouth. Use two straight lines as the top of the beak and the bottom of the jaw. Draw a curved line to show the ends of the beak and jaw. Sketch an oval for the body. Use curved lines to show the top of the neck and tail, as well as the positions of the legs.

For each step, draw lightly with your pencil.

2 Draw overlapping ovals and U-shaped figures to form the legs. Sketch gently curved lines to show the undersides of the neck, back part of the belly, and tail. Add the eye, ear, nostril, and tongue.

Coelophysis continued

3 Add straight lines to form the teeth. Use curved lines to make the neck look more muscular. Sketch the U-shaped feet, rectangular toes, and curved V-shaped claws. Make the shape of the head, beak, and jaw look more lifelike.

For each step, draw lightly with your pencil.

4 Smooth out all of the lines. Make the legs, feet, toes, and claws look more real. Draw a long clawed toe on the rear leg. Use curved lines to make the neck, body, legs, and tail look muscular. Add more details around the beak, jaw, eye, and ear.

Use a pen on the final drawing; then erase pencil marks.

Coelophysis continued

5 This is a detailed example of how the Coelophysis might have looked. Finish the drawing as shown here or try another idea of your own.

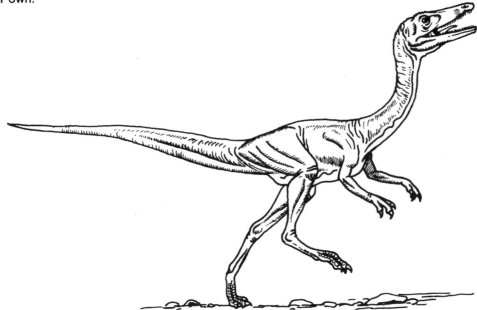

For each step, draw lightly with your pencil.

Deinonychus

1 Draw an oval for the body. For the head, draw the letter U on its right side, covering the open part of the U with a curved line. To form the mouth, use the letter V. Add curved lines to show the neck, legs, and tail.

2 Add details to the head to show the eye, nostril, mouth, and ear. Draw overlapping ovals to form the legs. Add curved lines to show the undersides of the neck, body, and tail.

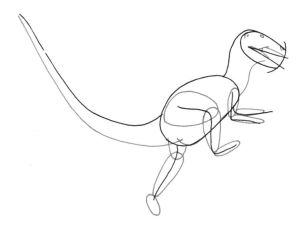

Use a pen on the final drawing; then erase pencil marks.

Deinonychus continued

3 Sketch the lower jaw, teeth, and the area between the eye and ear. Add a curved line to show the shoulder. Use circles, rectangles, and curved V-shaped figures to form rough outlines of the feet, toes, and claws. Notice the large claw on each of the two back feet.

4 Smooth out all of the lines. Add curved lines behind the ear and around the eye. Make the teeth look more real. Use gently curved lines to make the neck, body, legs, and tail look more muscular. Add the small toe that is raised above the other toes on the back foot.

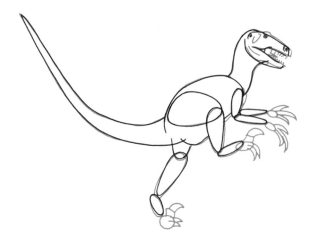

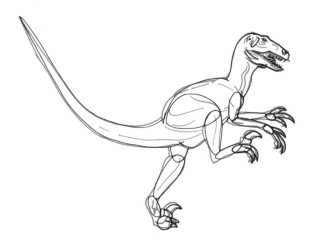

For each step, draw lightly with your pencil.

5 This is a detailed example of how the Deinonychus might have looked. Finish the drawing as shown here or try another idea of your own.

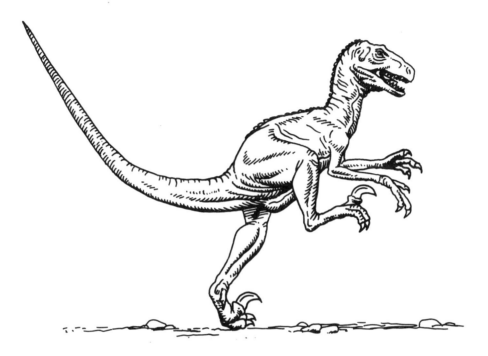

Iguanodon

1 Draw an oval for the head and a thinner overlapping oval for the snout. Add a straight line to form the mouth. Sketch a large oval for the body. Use curved lines to show the top of the neck and tail, as well as the positions of the legs.

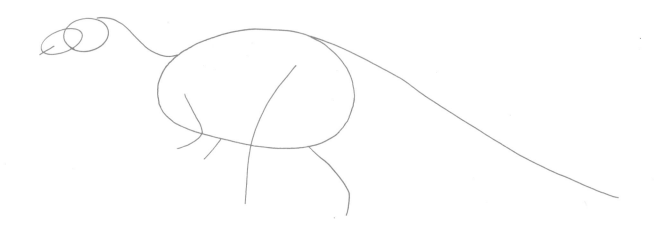

For each step, draw lightly with your pencil.

2 Draw overlapping ovals and U-shaped figures to form the legs. Sketch gently curved lines to show the undersides of the neck, belly, and tail. Add the eye, ear, and nostril. Bend the mouth line a little.

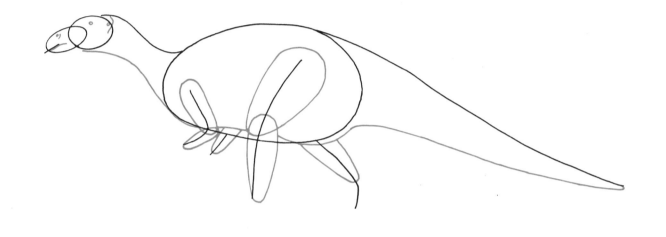

Iguanodon continued

3 Add curved lines below and behind the eye. Form the beak, eyebrows, and jaw by drawing more curved lines. Make the shape of the head look more lifelike. Sketch rectangles and U- and V-shaped figures to form rough outlines of the feet, toes, and claws.

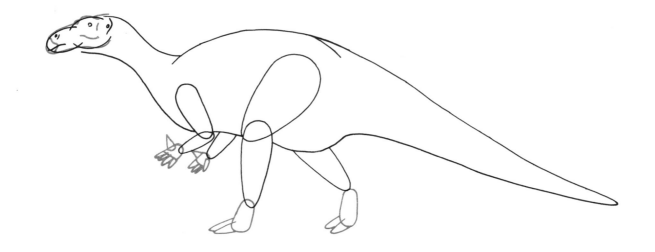

For each step, draw lightly with your pencil.

4 Smooth out all of the lines. Make the legs, feet, toes, and claws look more real. Use curved lines to make the neck, body, legs, and tail look more muscular. Add more details around the beak, jaw, eye, and ear.

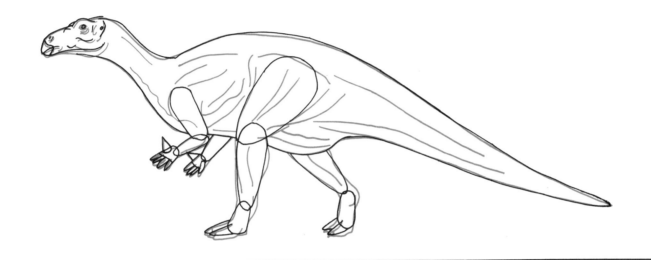

Use a pen on the final drawing; then erase pencil marks.

Iguanodon continued

5 This is a detailed example of how the Iguanodon might have looked. Finish the drawing as shown here or try another idea of your own.

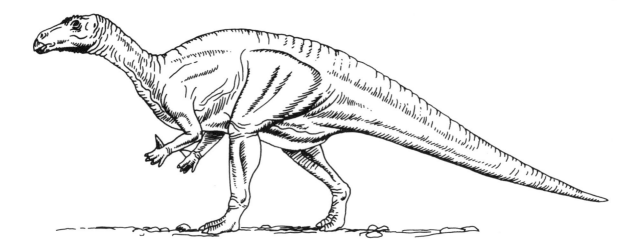

For each step, draw lightly with your pencil.

Apatosaurus

1 For the body, draw a large oval. Draw a small oval for the head and a straight line for the mouth. Use gently curved lines to show the top of the neck and tail, as well as the positions of the legs.

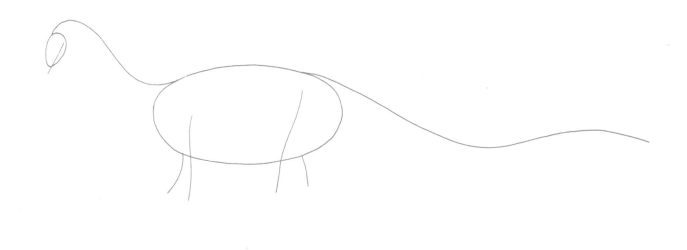

Apatosaurus continued

2 Draw overlapping ovals to form the legs. Sketch gently curved lines to show the undersides of the neck, body, and tail. Add the eye and ear, and make the mouth look more real.

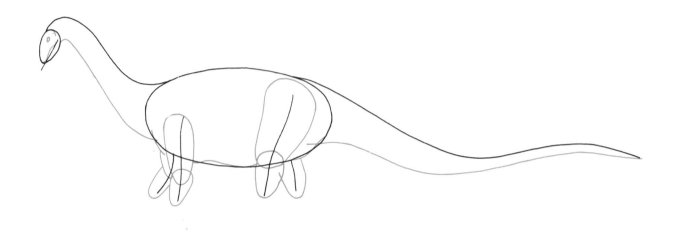

For each step, draw lightly with your pencil.

3 Add the shoulder and hip bones. Draw small circles and U-shaped figures to form rough outlines of the feet, toes, and claws. Make the shape of the head look more lifelike.

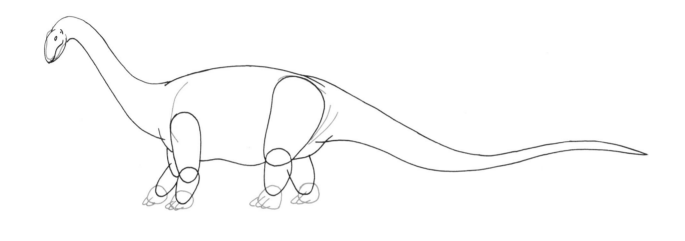

Use a pen on the final drawing; then erase pencil marks.

Apatosaurus continued

4 Smooth out all of the lines. Make the feet, toes, and claws look more real. Use gently curved lines to make the neck, body, legs, and tail look muscular. Add more details around the eye and ear.

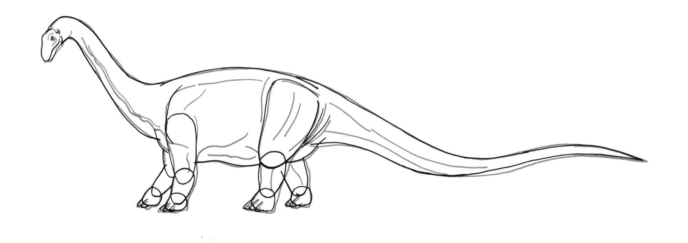

For each step, draw lightly with your pencil.

5 This is a detailed example of how the Apatosaurus (more often called the Brontosaurus) might have looked. Finish the drawing as shown here or try another idea of your own.

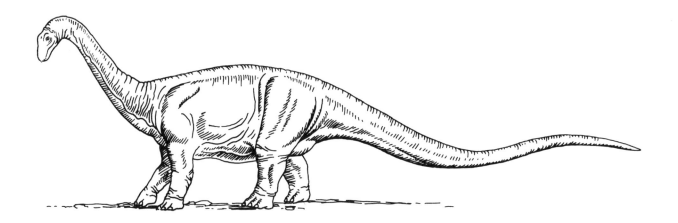

Ultrasaurus

1 Draw a small circle for the head. Add the letter V to form the mouth. Use two straight lines as the top of the beak and the bottom of the jaw. Draw a curved line to show the ends of the beak and jaw. Sketch a long oval for the body. Use gently curved lines to show the top of the neck and tail, as well as the positions of the legs.

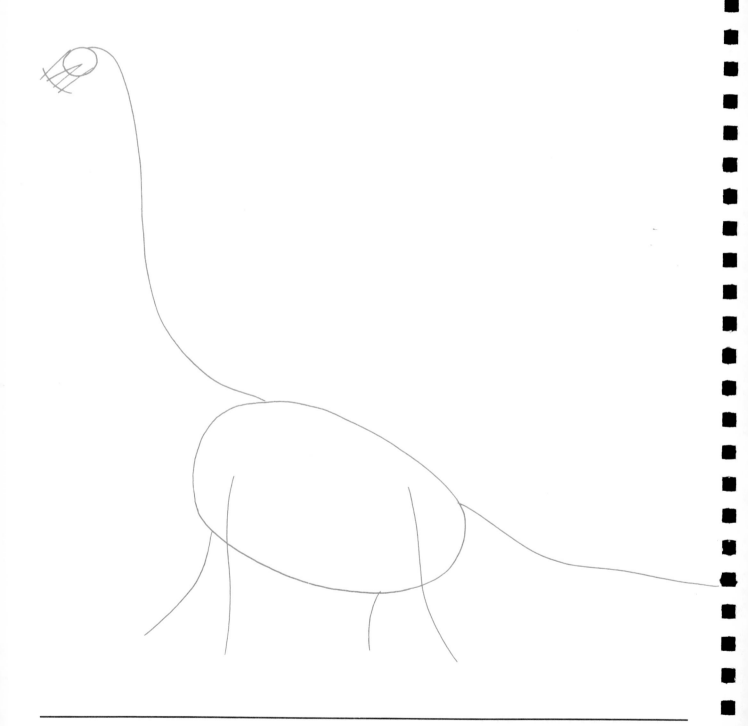

For each step, draw lightly with your pencil.

2 Draw overlapping ovals and U-shaped figures to form the legs. Sketch gently curved lines to show the shape of the undersides of the neck, chest, and tail. Add the eye, ear, nostril, and the bump on the beak. Make the mouth look more lifelike.

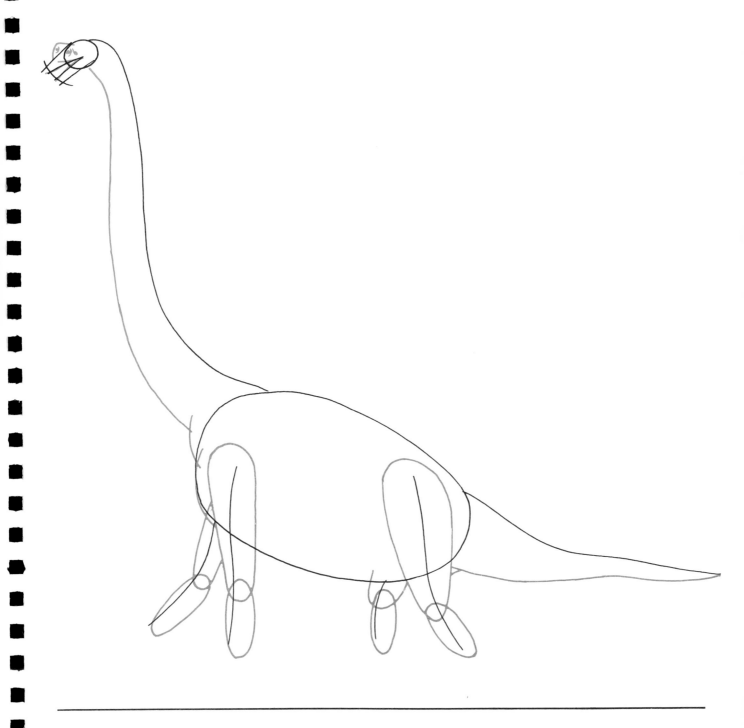

Use a pen on the final drawing; then erase pencil marks.

Ultrasaurus continued

3 Sketch the teeth, and make the beak and jaw look more real. Use curved lines to show the ribs and the shoulder and hip bones. Make the neck, body, legs, and tail look more muscular by adding more curved lines. Draw small rounded rectangles and U-shaped figures to form rough outlines of the feet, toes, and claws.

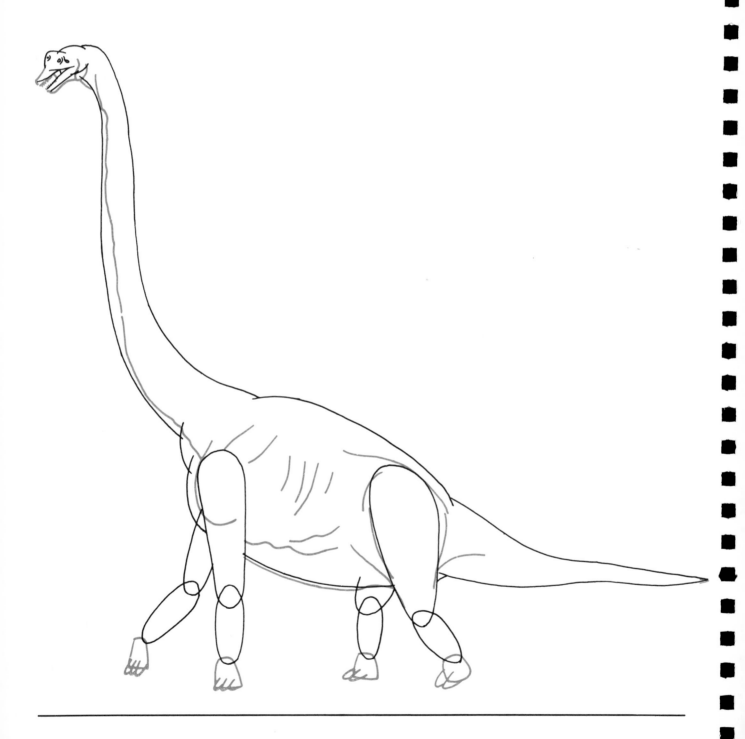

For each step, draw lightly with your pencil.

4 Smooth out all of the lines. Make the feet, toes, and claws look more lifelike. Draw curved lines to make the neck, body, legs, and tail look more muscular. Add more details around the eye, nose, and ear.

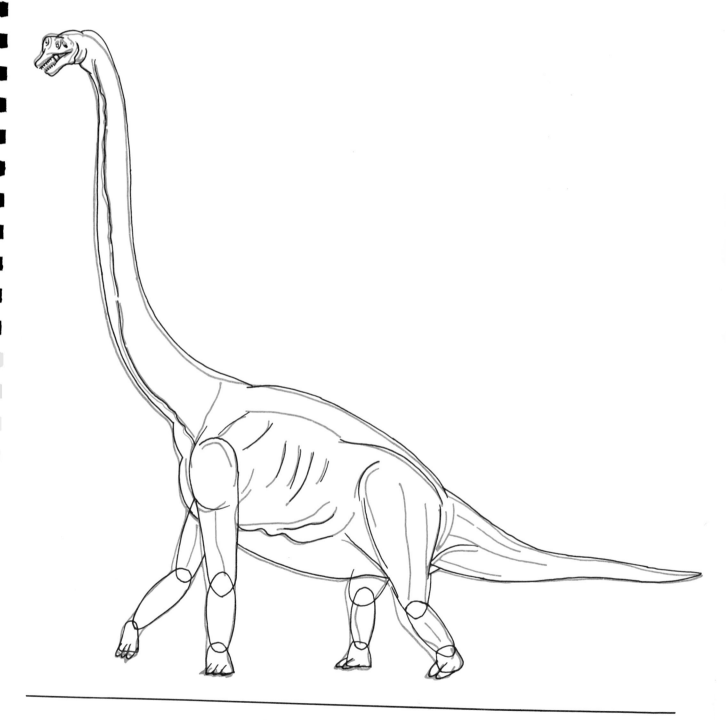

Use a pen on the final drawing; then erase pencil marks.

Ultrasaurus continued

5 This is a detailed example of how the Ultrasaurus might have looked. Finish the drawing as shown here or try another idea of your own.

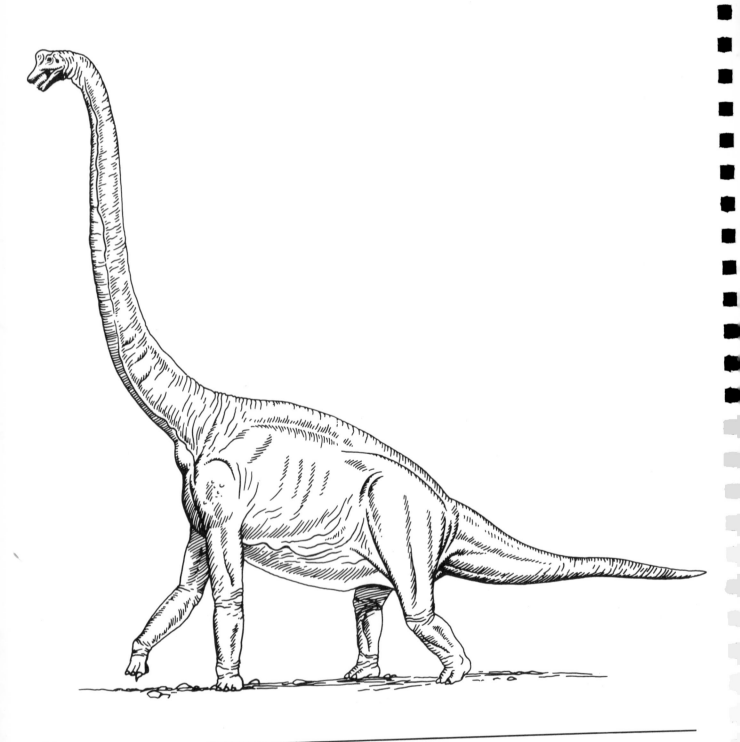

For each step, draw lightly with your pencil.

Plateosaurus

1 Draw a small oval for the head. Add the letter V to form the mouth. Sketch a large potato shape for the body. Use curved lines to show the top of the neck and tail, as well as the positions of the legs.

Use a pen on the final drawing; then erase pencil marks.

Plateosaurus continued

2 Draw overlapping ovals and U-shaped figures to form the legs. Sketch gently curved lines to show the undersides of the neck, chest, and tail. Add the eye, ear, nostril, and cheek.

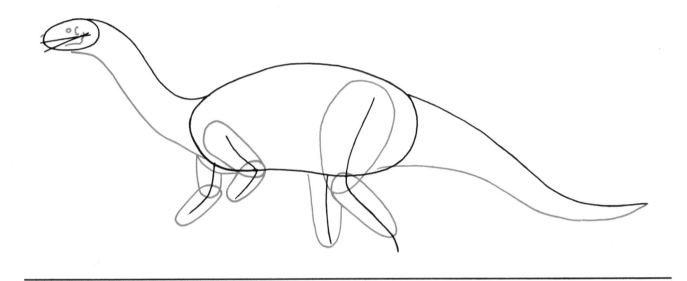

For each step, draw lightly with your pencil.

3 Make the head, beak, and jaw look more real. Use a curved line to join the bottom of the body to the tail. Draw small squares and triangles to form rough outlines of the feet, toes, and claws.

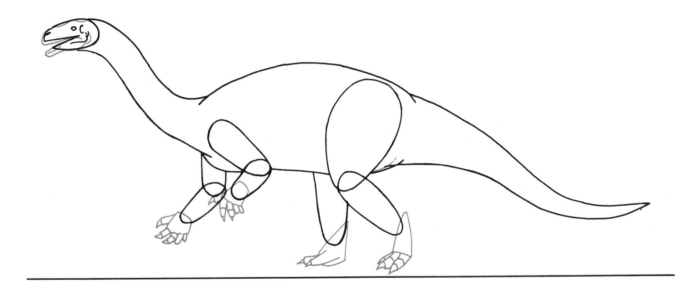

Use a pen on the final drawing; then erase pencil marks.

Plateosaurus continued

4 Smooth out all of the lines. Make the feet, toes, and claws look more lifelike. Use curved lines to show the ribs and the shoulder and hip bones. Draw more lines to make the neck, body, legs, and tail look more muscular. Add the teeth and more details around the eye, nose, and ear.

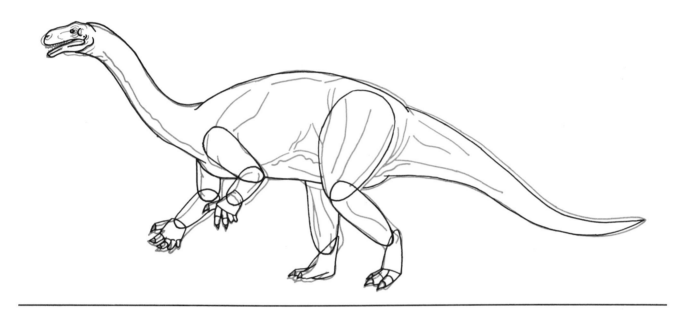

For each step, draw lightly with your pencil.

5 This is a detailed example of how the Plateosaurus might have looked. Finish the drawing as shown here or try another idea of your own.

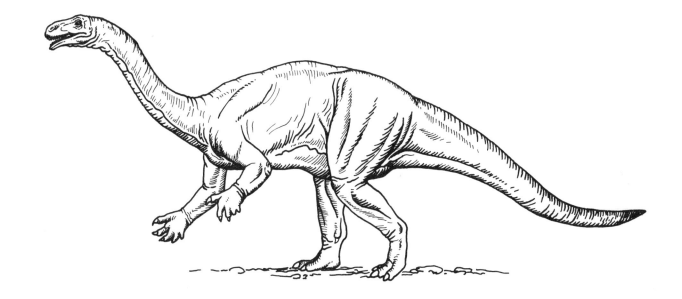

Elasmosaurus

1 Draw a small circle for the head. Add the letter V to form the mouth. Use two straight lines as the top of the beak and the bottom of the jaw. Draw a curved line to show the ends of the beak and jaw. Sketch a long oval for the body. Use gently curved lines to show the top of the neck and tail, as well as the positions of the fins.

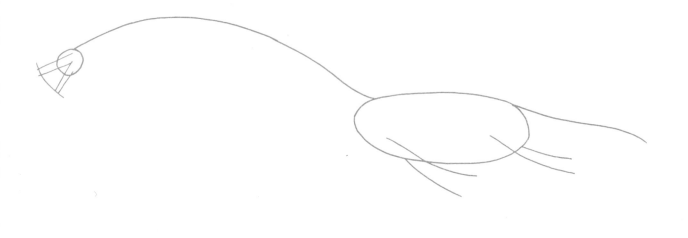

For each step, draw lightly with your pencil.

2 Add more details to the mouth and head. Sketch the outlines of the fins. Use gently curved lines for the bottom of the neck and tail.

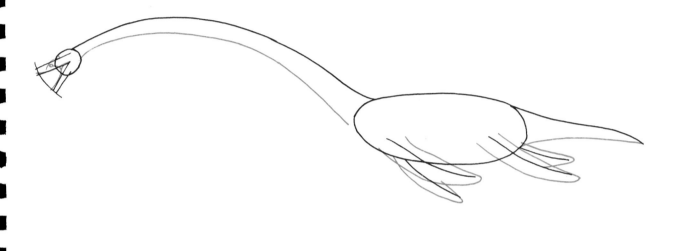

Elasmosaurus continued

3 Sketch the teeth, and add more details to the beak, jaw, and head. Use gently curved lines to form the shoulders of the front and rear fins.

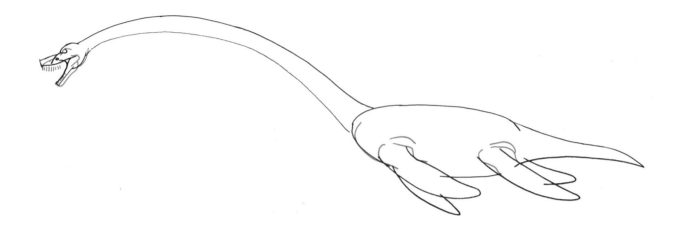

For each step, draw lightly with your pencil.

4 Smooth out all of the lines. Make the teeth look more lifelike. Use gently curved lines to make the neck, body, legs, and tail look more muscular.

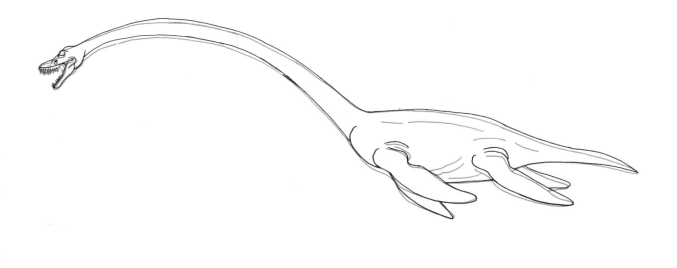

Elasmosaurus continued

5 This is a detailed example of how the Elasmosaurus might have looked. Finish the drawing as shown here or try another idea of your own.

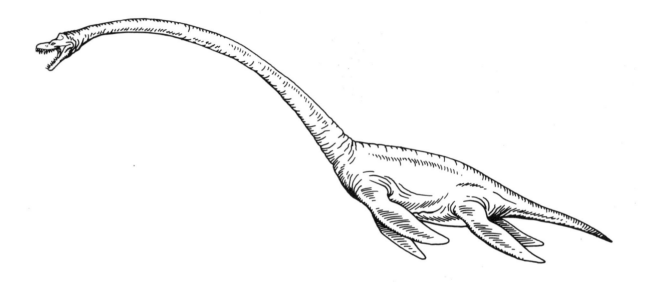

For each step, draw lightly with your pencil.

Allosaurus

1 For the head, draw a small oval. Use the letter V to form the mouth. Sketch a large egg shape for the body. Add gently curved lines to show the top of the neck and tail, as well as the positions of the legs.

Use a pen on the final drawing; then erase pencil marks.

Allosaurus continued

2 Draw overlapping ovals and U-shaped figures to form the legs. Sketch gently curved lines to show the undersides of the neck, body, and tail. Add the eye, ear, and nostril.

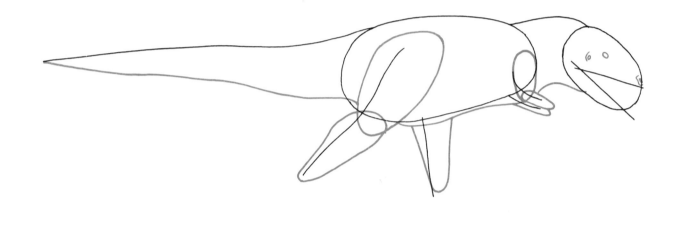

For each step, draw lightly with your pencil.

3 Draw short straight lines to show the teeth. Sketch a curved V-shaped figure to form a bump on the beak. Make the head, beak, and jaw look more lifelike. Use gently curved lines to show the hip bone and to join the bottom of the body to the tail. Draw rectangles, curved lines, and U- and V-shaped figures to form rough outlines of the feet, toes, and claws.

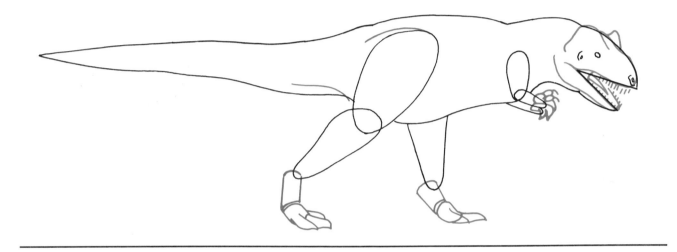

Allosaurus continued

4 Smooth out all of the lines. Make the teeth, feet, toes, and claws look more real. Use curved lines to show the ribs and shoulder. Draw more lines to make the neck, body, legs, and tail look more muscular. Add more details around the beak, jaw, eye, and ear.

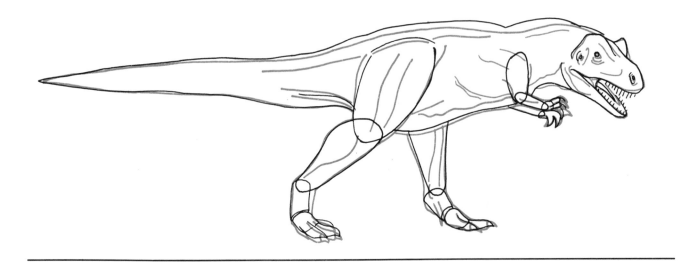

For each step, draw lightly with your pencil.

5 This is a detailed example of how the Allosaurus might have looked. Finish the drawing as shown here or try another idea of your own.

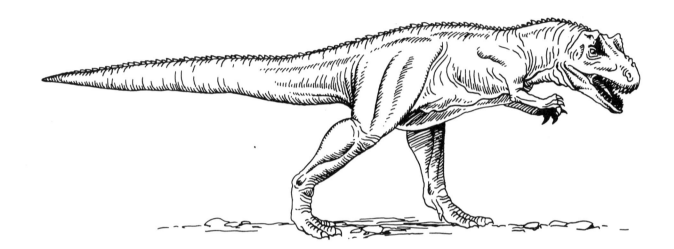

Spinosaurus

1 Draw a circle for the head. Add the letter V to form the mouth. Use two straight lines as the top of the beak and the bottom of the jaw. Draw a curved line to show the ends of the beak and jaw. Sketch a large potato shape for the body. Use gently curved lines to show the top of the neck and tail, as well as the positions of the legs.

For each step, draw lightly with your pencil.

2 Draw overlapping ovals and U-shaped figures to form the legs. Sketch gently curved lines to show the undersides of the neck, chest, back part of the belly, and tail. Add the eye, ear, and nostril, as well as more details to the mouth. Place the spiny fin on the back by drawing a long curved line above the back from the neck to the tail. Then connect this curved line to the back with several open-ended tubes.

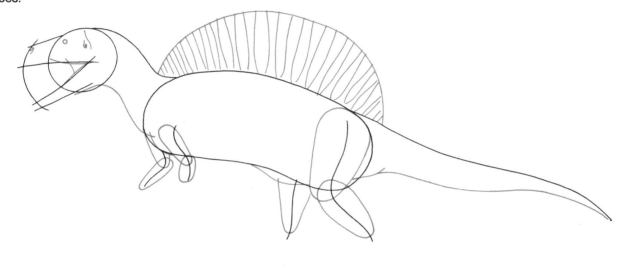

Spinosaurus continued

3 Add gently curved lines to show the shoulder and hip bones. Sketch short lines to show the positions of the teeth. Use rectangles, circles, and curved V-shaped figures to form rough outlines of the tongue, feet, toes, and claws. Make the shape of the head, beak, and jaw look more lifelike.

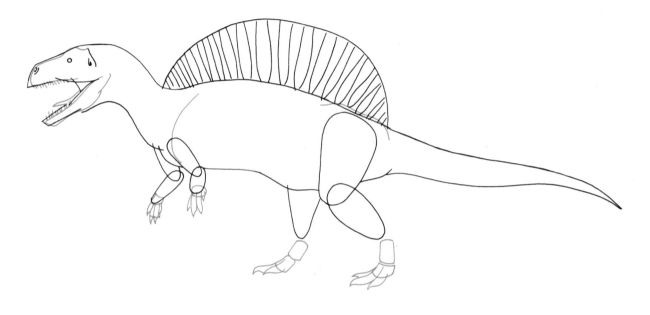

For each step, draw lightly with your pencil.

4 Smooth out all of the lines. Make the teeth, feet, toes, and claws look more real. Use curved lines to show the ribs and make the neck, body, legs, and tail look more muscular. Add more details around the beak, jaw, eye, and ear.

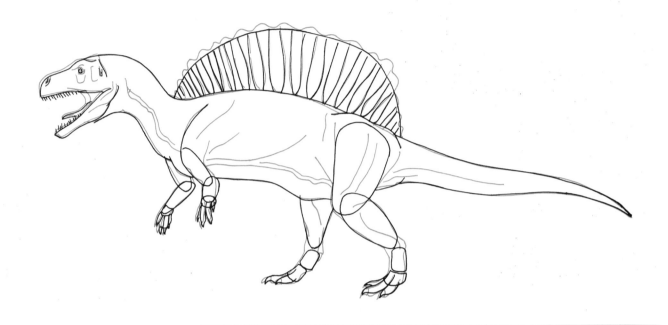

Spinosaurus continued

5 This is a detailed example of how the Spinosaurus might have looked. Finish the drawing as shown here or try another idea of your own.

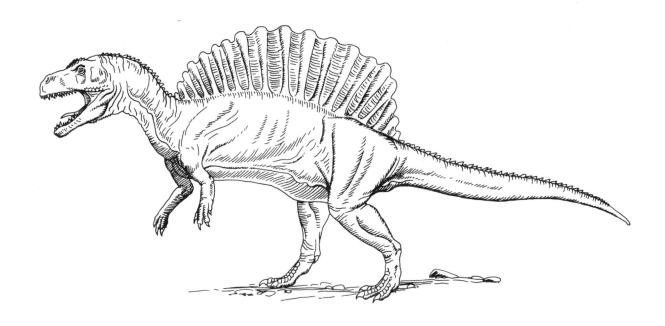

For each step, draw lightly with your pencil.

Dimetrodon

1 For the head, draw an oval. Add the letter V to form the mouth. Sketch a long potato shape for the body. Use curved lines to show the top of the neck and the positions of the legs.

Use a pen on the final drawing; then erase pencil marks.

Dimetrodon continued

2 To form the legs, draw overlapping ovals and a U-shaped figure. Sketch gently curved lines to show the neck, fin, and tail. Add the eye, ear, and nostril.

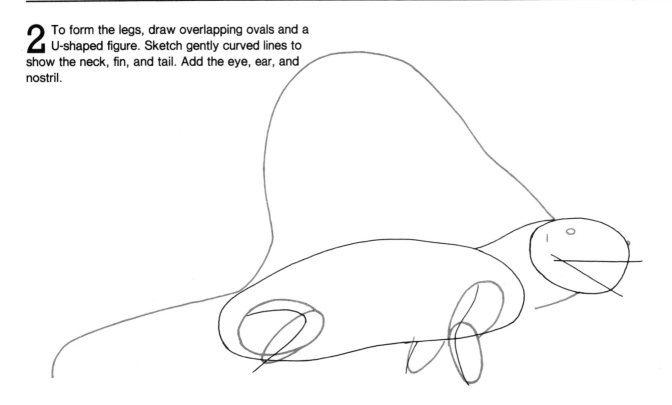

For each step, draw lightly with your pencil.

3 Draw short straight lines to show the positions of the teeth. Use complete and partial triangles to form rough outlines of the feet. Make the top of the fin and the mouth and jaw look more lifelike. Use gently curved lines to show the bottom and tip of the tail and part of the neck. Sketch the eyebrow.

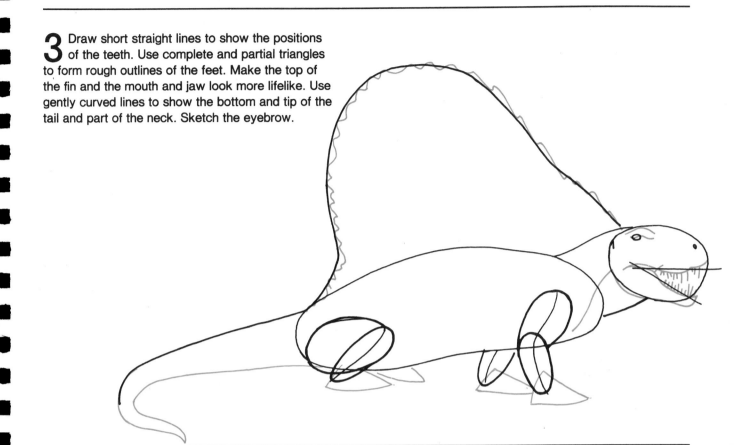

Use a pen on the final drawing; then erase pencil marks.

Dimetrodon continued

4 Smooth out all of the lines. Make the teeth, mouth, feet, toes, and claws look more lifelike. Use curved lines to show the ribs and the shoulder and hip bones. Make the neck, body, legs, and tail look more muscular by sketching more curved lines. Add more details around the beak, jaw, eye, and ear. Draw spines in the fin and tiny ridges along the top of the tail.

For each step, draw lightly with your pencil.

5 This is a detailed example of how the Dimetrodon might have looked. Finish the drawing as shown here or try another idea of your own.

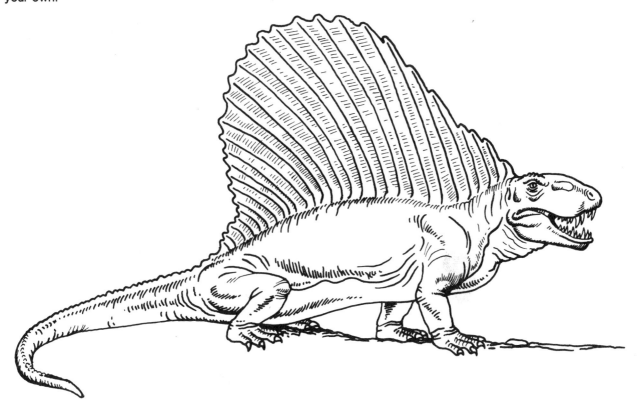

Triceratops

1 To form the head and snout, draw two slightly overlapping circles. Connect the tops and bottoms of the circles with straight lines. Add a U-shaped figure for the mouth. Sketch a large oval for the body. Draw gently curved lines to show the top of the tail, bottom of the neck, and the positions of the legs.

2 Sketch the eye, ear, and nostril. Use overlapping ovals and U-shaped figures to form the legs. Add the letter V for the horn on the snout. Draw long, skinny V-shaped figures that are slightly curved for the two horns at the top of the head. Connect two uneven U-shaped figures to form the crest. Use a gently curved line to show the underside of the tail.

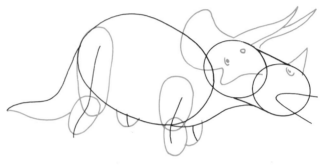

For each step, draw lightly with your pencil.

3 Draw two mushroom-shaped figures. The top figure will form the beak and the other figure (split in half) will make up the lower jaw and inside of the mouth. Draw several small circles and rounded triangles to form horns along the crest. Use small ovals and rounded rectangles to form rough outlines of the feet, toes, and claws. Add gently curved lines over the eye, at the base of the rear horn, and to form the belly.

4 Smooth out all of the lines. Add more details around the horns, beak, jaw, eye, and ear. Make the head, legs, feet, toes, and claws look more real. Use curved lines to make the neck, body, legs, and tail look more muscular.

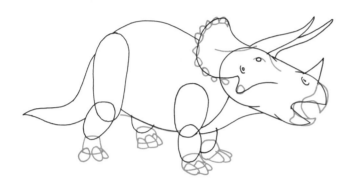 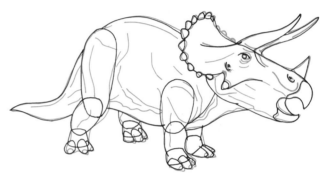

Use a pen on the final drawing; then erase pencil marks.

Triceratops continued

5 This is a detailed example of how the Triceratops might have looked. Finish the drawing as shown here or try another idea of your own.

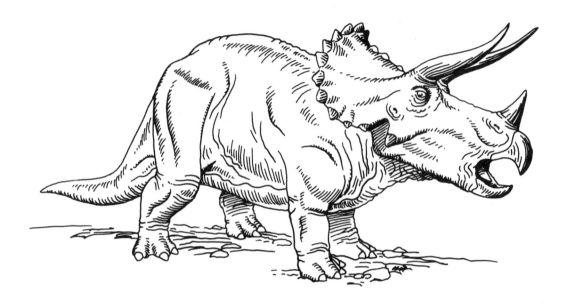

For each step, draw lightly with your pencil.

Ankylosaurus

1 Draw two small ovals for the head and the tip of the tail. Add a large oval for the body. Use a straight line for the mouth. Sketch curved lines to show the top of both the neck and the tail, as well as the positions of the legs.

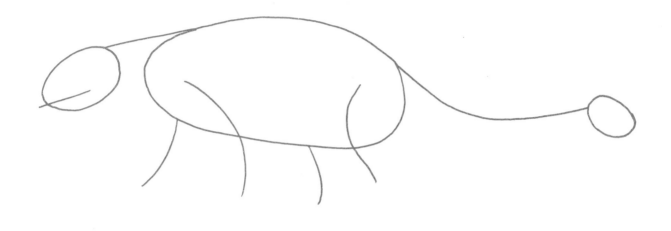

Ankylosaurus continued

2 Draw overlapping ovals and U-shaped figures to form the legs. Sketch gently curved lines to show the undersides of the neck, belly, and tail. Add the eye and nostril.

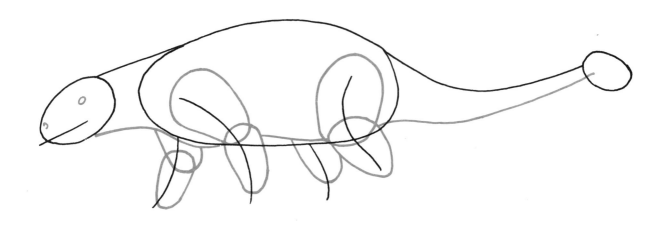

For each step, draw lightly with your pencil.

3 Use many gently curved lines to form ridges along the top of the head, body, and tail. Draw uneven triangles for the beak and jaw. Sketch similar triangles for the horns near the front and rear of the top of the body. Add a few rounded triangles along the top and side of the head and neck. Make the tip of the tail look like an apple with a small "nose."

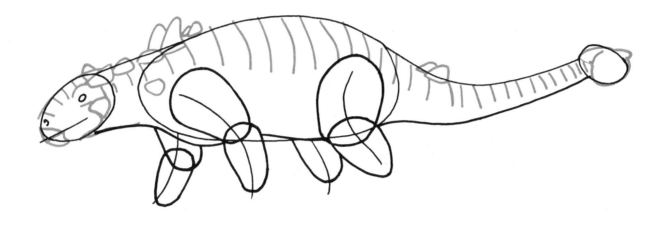

Ankylosaurus continued

4 Smooth out all of the lines. Add more details around the nostril, mouth, eye, and ear. Make the head, legs, feet, toes, and claws look more real. Use curved lines to show the jawbone and to make the neck, belly, legs, and tail look more muscular. Sketch some circles down the front leg, putting X's through them.

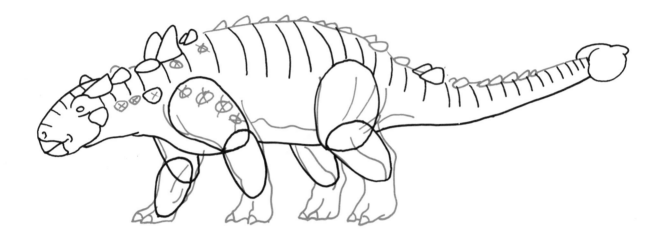

For each step, draw lightly with your pencil.

5 This is a detailed example of how the Ankylosaurus might have looked. Finish the drawing as shown here or try another idea of your own.

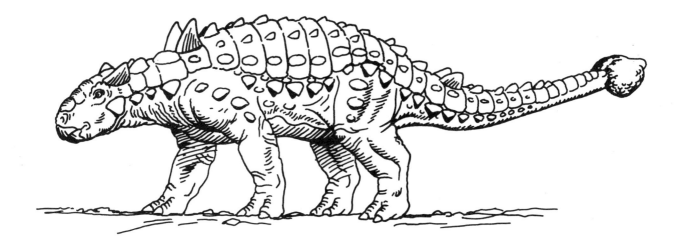

Stegosaurus

1 For the head, draw a small circle. Add an oval
that overlaps halfway into the head to form the
snout. To show where the mouth will be, draw a
wishbone shape. For the body, sketch a large egg
shape. Use gently curved lines to show the positions
of the legs and the tops of both the neck and the tail.

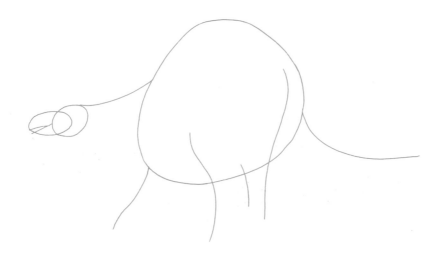

For each step, draw lightly with your pencil.

2 Add details to show the nostril, eye, and rear of the head. Draw overlapping ovals and U-shaped figures to form the legs. Add curved lines to show the undersides of both the body and the tail.

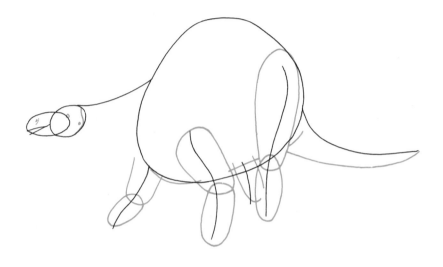

Use a pen on the final drawing; then erase pencil marks.

Stegosaurus continued

3 Use slanted rectangles as rough outlines of the feet. Add small ovals and U-shaped figures for the toes and claws. Make the shape of the head, beak, and lower jaw more lifelike. Use curved lines to show the shoulder and the bottom of the neck. Draw the V-shaped and five-sided spines on the back and tail.

For each step, draw lightly with your pencil.

4 Smooth out all of the lines, especially those that make up the legs, feet, toes, and claws. Add details to the eye and cheek area. Use gently curved lines to make the body, legs, and tail look more muscular.

Stegosaurus continued

5 This is a detailed example of how the Stegosaurus might have looked. Finish the drawing as shown here or try another idea of your own.

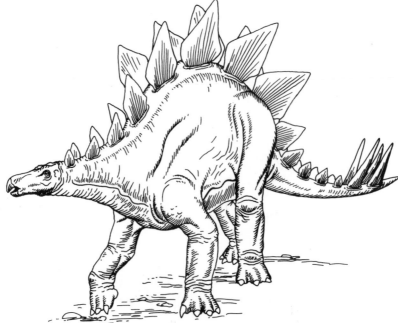

For each step, draw lightly with your pencil.